SuperVisions

AMBIGUOUS OPTICAL ILLUSIONS

Al Seckel

Sterling Publishing Co., Inc.
New York

Art credits, courtesy and copyright the artist:
pp. 17, 27, 30, 37, 56, 66, 89—Sandro Del-Prete;
p. 19—Shigeo Fukuda;
p. 82—Keith Kaye;
p. 36—Scott Kim;
p. 90—Ken Knowlton;
pp. 81, 84—Ken Landry;
pp. 23, 31, 50, 62, 71, 77, 80, 85, 87—Octavio Ocampo;
pp. 6, 16, 41, 61—István Orosz

Book Design: Lucy Wilner
Editor: Rodman Pilgrim Neumann

Library of Congress Cataloging-in-Publication Data
Seckel, Al.
 Ambiguous optical illusions / Al Seckel.
 p. cm. -- (Super visions)
 Includes index.
 ISBN 1-4027-1829-2
 1. Optical illusions--Juvenile literature. I. Title. II. Series.

 QP495.S43 2005
 152.14'8--dc22

 2004019482

 10 9 8 7 6 5 4 3 2 1

Published by Sterling Publishing Co., Inc.
387 Park Avenue South, New York, NY 10016
© 2005 by Al Seckel
Distributed in Canada by Sterling Publishing
ᶜ/o Canadian Manda Group, 165 Dufferin Street
Toronto, Ontario, Canada M6K 3H6
Distributed in Great Britain by Chrysalis Books Group PLC
The Chrysalis Building, Bramley Road, London W10 6SP, England
Distributed in Australia by Capricorn Link (Australia) Pty. Ltd.
P.O. Box 704, Windsor, NSW 2756, Australia
Printed in China

Sterling ISBN 1-4027-1829-2

CONTENTS

INTRODUCTION

Inside this book you will find images that will flip-flop back and forth. One moment you are seeing one thing, and then the next moment something completely different and unexpected! This normally does not happen in your experience of viewing the world. Luckily, your normal view of the world is stable.

Although in some sense, all the illusions in this book are puzzlers, they are not an intelligence test. They are just fun! They are meant to make you laugh and give you joy. Sometimes, you will see the answer simply by staring at the image and the new interpretation will "pop" into your awareness. Other images might require inverting or slightly rotating the image to see a different interpretation. Some images may not make any sense at all when you first look at them, but before long your brain will organize the image, and it will then make sense. Strangely, after you do this, you will never be able to see the meaningless interpretation again.

Have fun with this collection, which contains not only some familiar classic illusions, but also some previously unpublished ones. Share them with your friends and try to test the differences in how fast your friends see the alternate interpretations.

—Al Seckel

A Mouse Playing Hide and Seek with a Cat

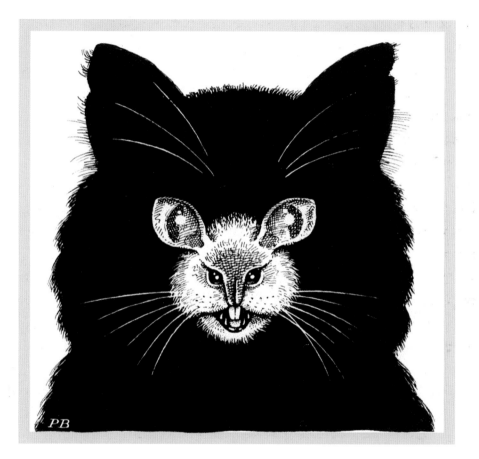

Can you find where the mouse is hiding from the cat?

Homage to William Shakespeare

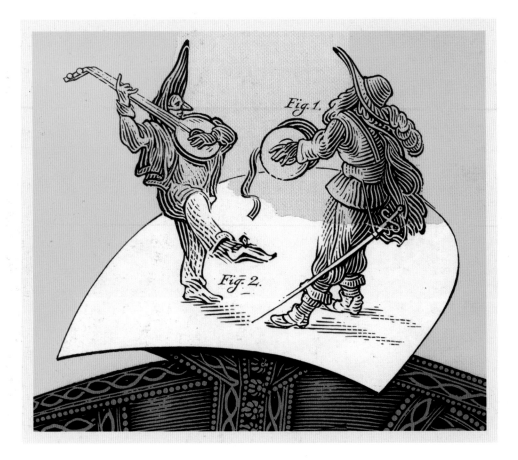

Two minstrels pay homage to sixteenth-century English playwright William Shakespeare.

Desert Mirage

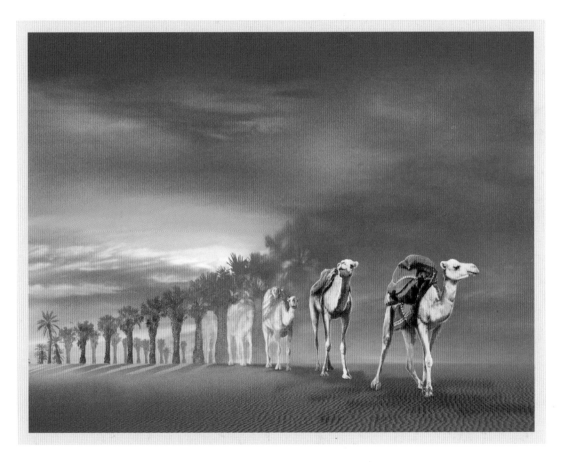

A strange type of desert mirage.

A Change of Mind

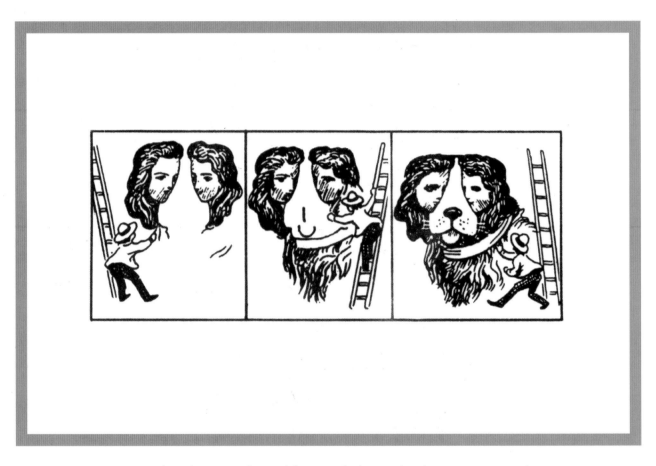

It seems that the artist changed his mind about what he was going to draw.

A Strange Coincidence

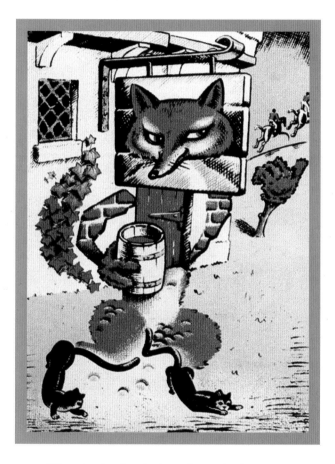

How is the fox hiding from the hunters?

Two Bodies and Only One Head

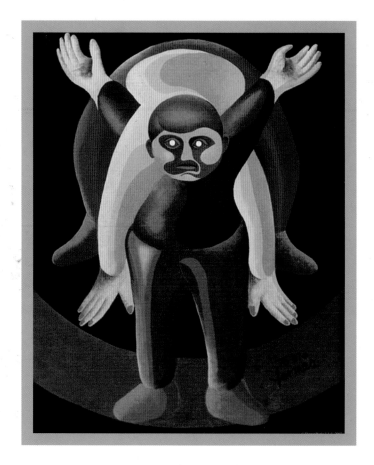

How is this possible?

Arcimboldo's Fruit Head

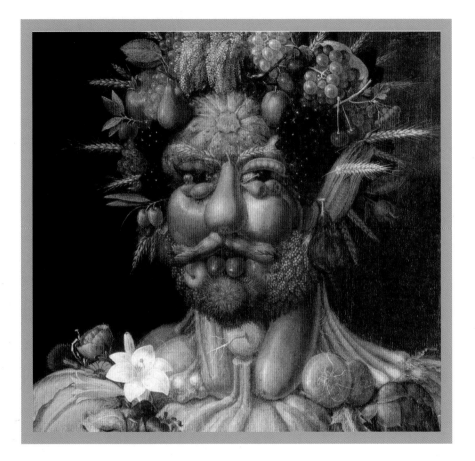

Do you see a man or a collection of fruit?

A Strange Twist

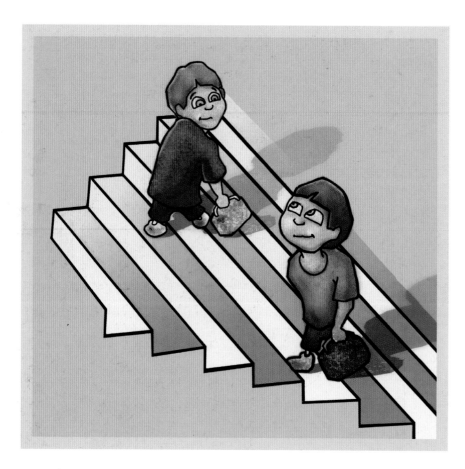

There is something twisted about these stairs. Can you find it?

Bull's-eye

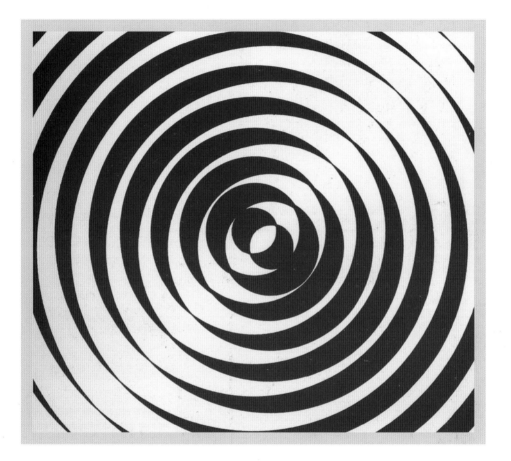

Stare at these rings and they will change direction.

The Tomb of Napoleon

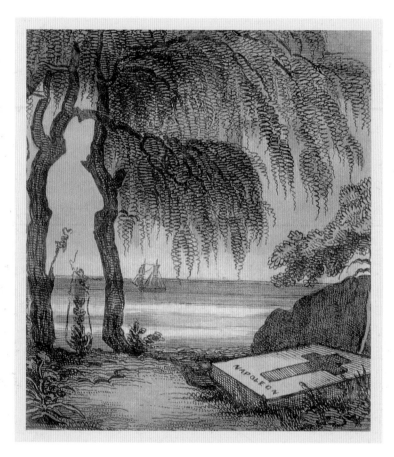

Can you find the standing figure of Napoleon?

Tessellating Fish

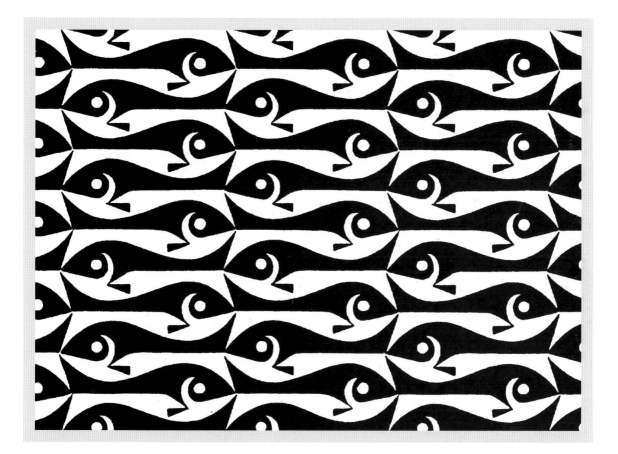

If you stare at the fish, they will reverse direction.

Voltaire's Map

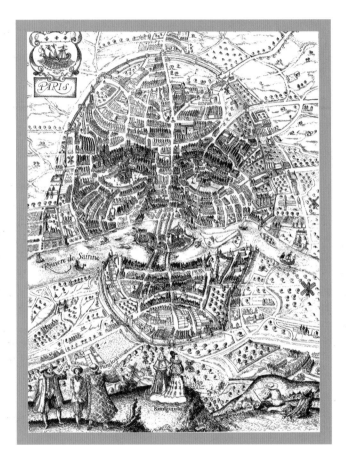

Can you find Voltaire's head in this map of eighteenth century Paris?

Saint George and the Dragon

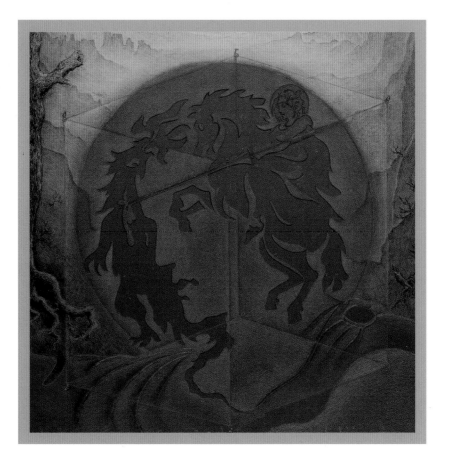

*Can you find a portrait of both Saint George,
and his battle with a dragon?*

A Painting in the Background

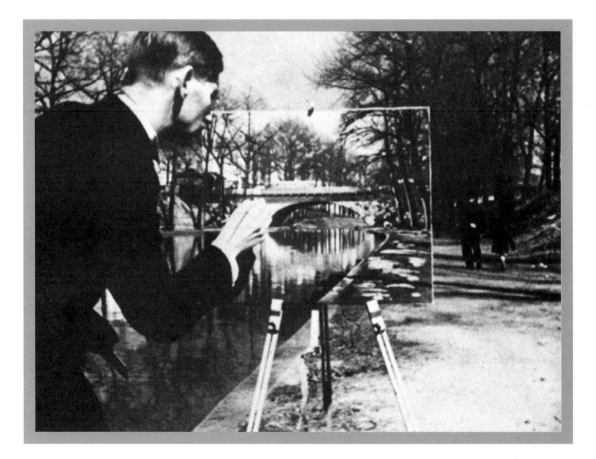

There is something funny about what he is painting.

Legs of Two Different Genders

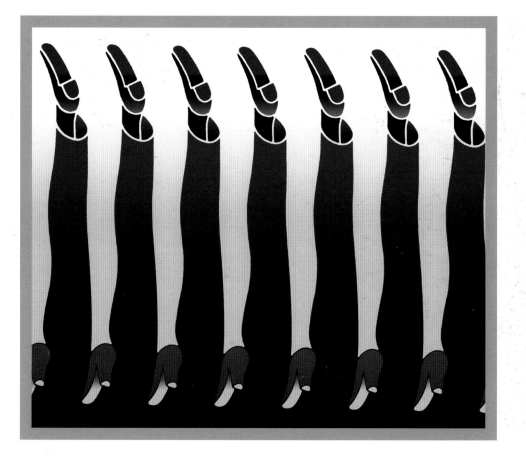

Can you find both male and female legs?

A Figure/Ground Illusion

Can you find the cow's head?

A Playwright's Vision

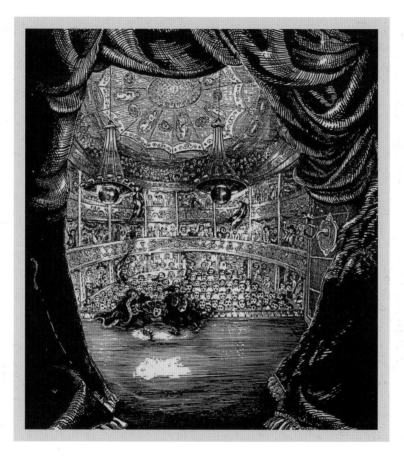

A playwright has to envision not only the stage, but also his audience.

The Old Woman/Young Woman Illusion

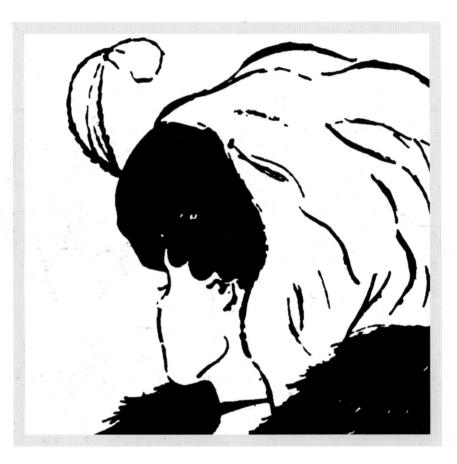

Can you find both an old woman and a young woman?

A Figure/Ground Illusion

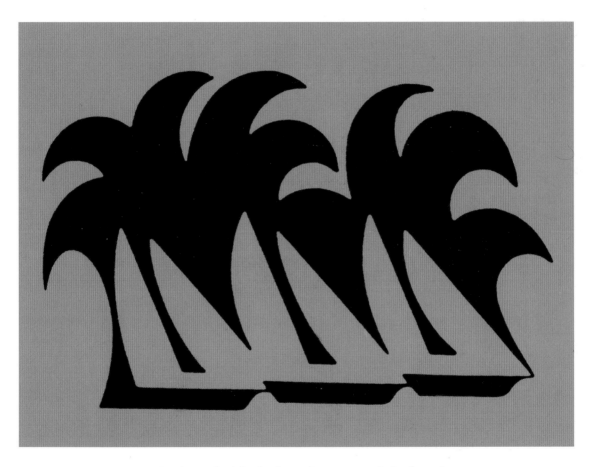

Can you find both the palm trees and the boats?

All at Once

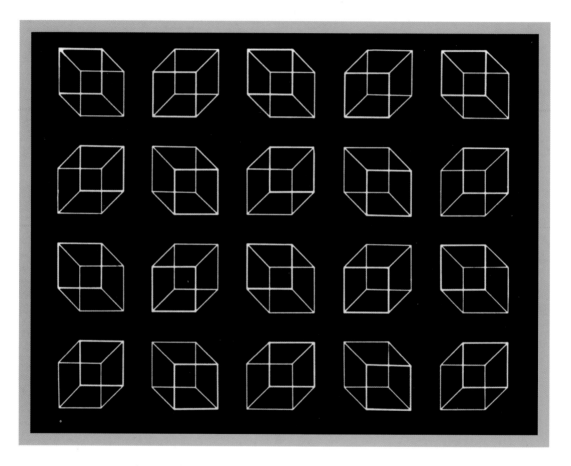

Stare at these cubes and they will all spontaneously reverse direction.

The Flowering of Love

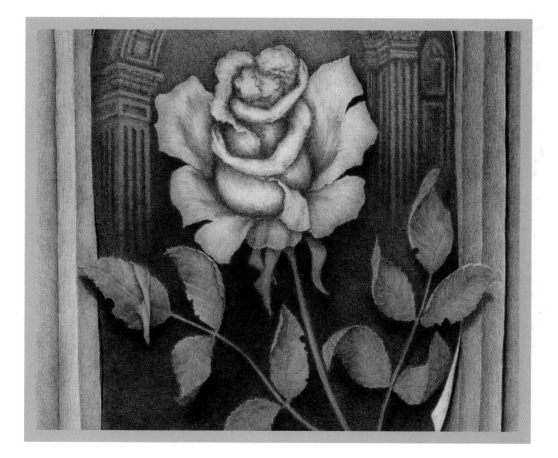

Can you find the couple hiding in the pedals of the rose?

What's This?

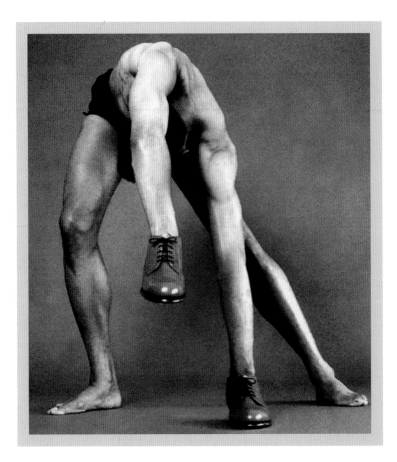

What is going on here?

All is Vanity

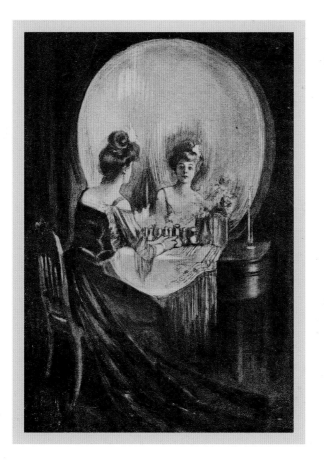

The future does not look too bright for this woman.

The Invisible Neptune

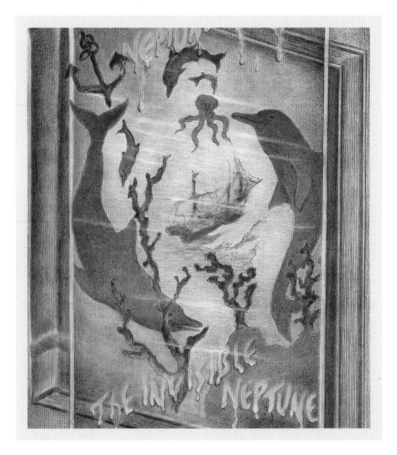

Can you find both Neptune and his dolphins?

Marlene Dietrich

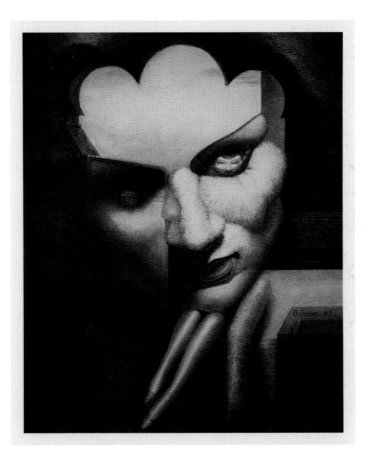

Can you find both the head of Marlene as well as her sitting in a train station?

Ten Bodies and Only Five Heads

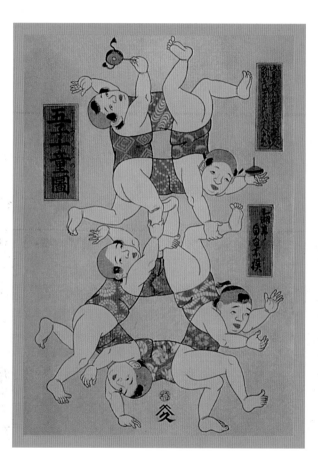

How can ten bodies have only five heads?

A Strange Coincidence

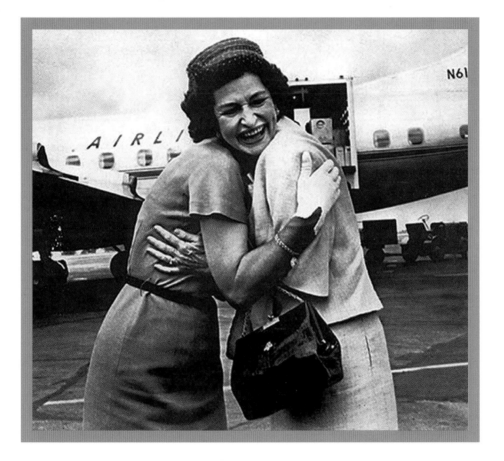

To which body does this head belong?

A Strange Meshing of Gears

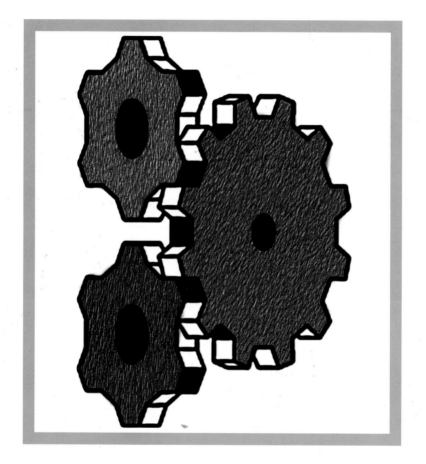

Will these gears really work?

Climbing the Face of the Mountain

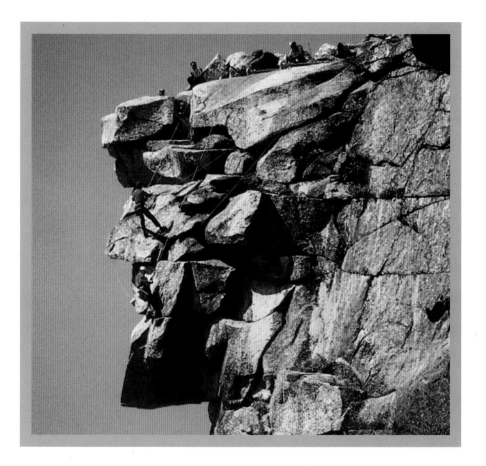

These climbers are literally climbing the face of the mountain.

Kim's Paradox

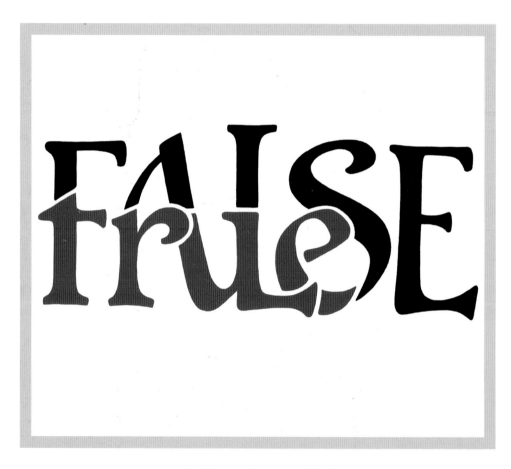

Is this word true or false?

Homage to Leonardo da Vinci

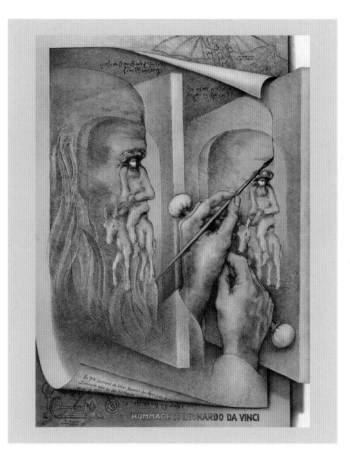

*Is Leonardo da Vinci drawing a scene of
a mule and rider or his own profile?*

Corporal Violet

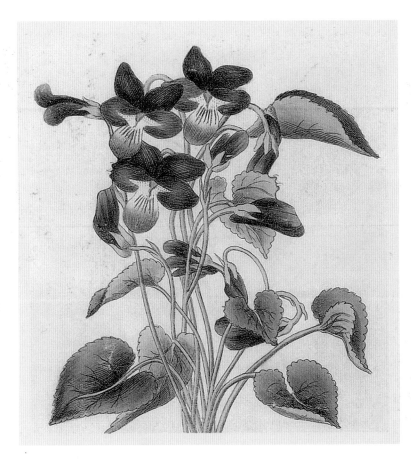

Can you find the three profiles hiding in the leaves?

Figure/Ground Illusion

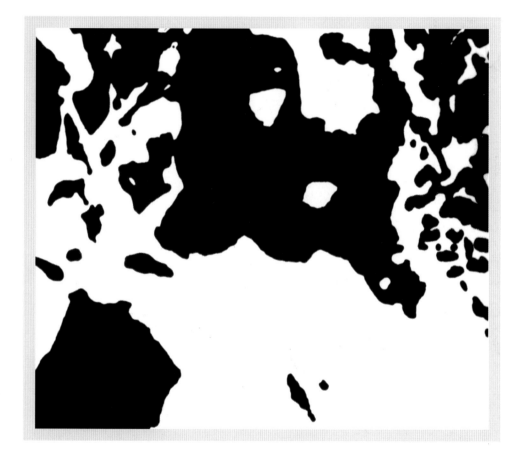

Can you find the bearded man?

Death Lurking

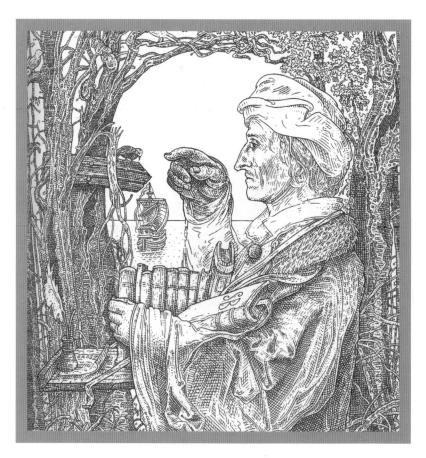

Can you find the hidden skull?

The Map of Christopher Columbus

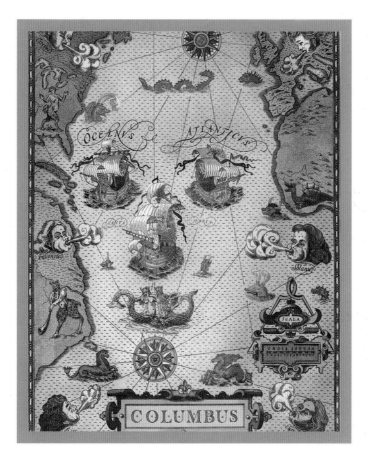

*Can you find the famous American Explorer
Christopher Columbus in this map?*

A Portent of Danger

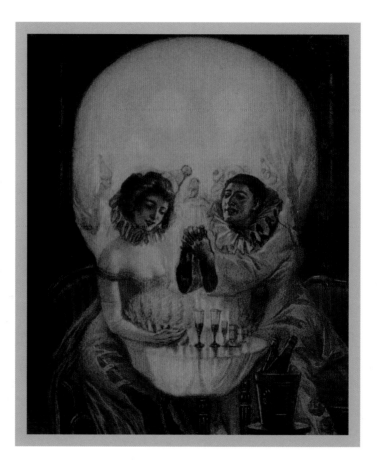

Is there danger lurking for this couple?

Let Sleeping Dogs Lie

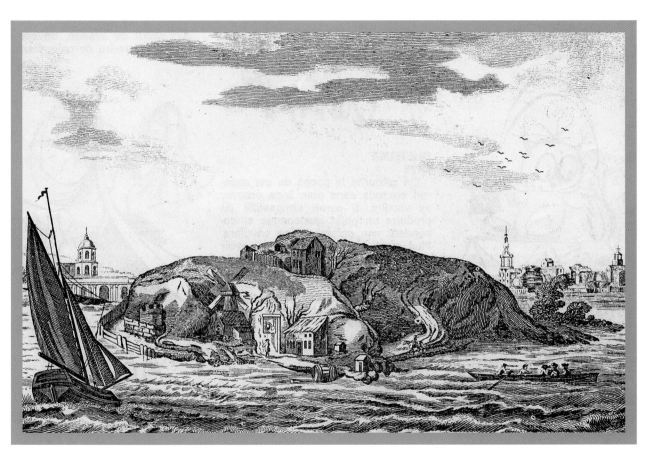

On this island, they have a saying: "Let sleeping dogs lie."

The Librarian

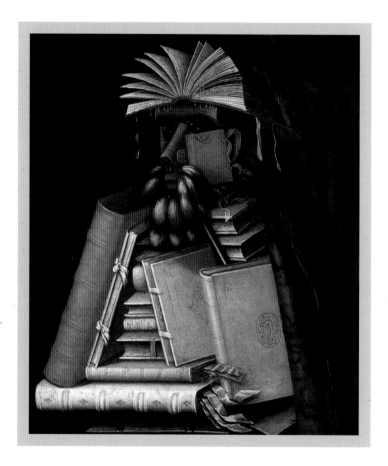

Is this man well-read?

Figure/Ground Illusion

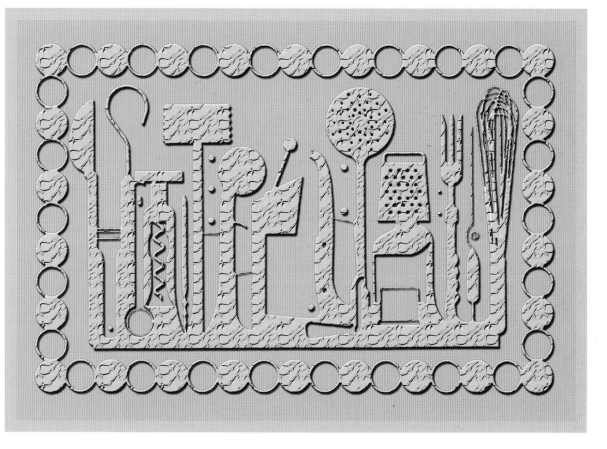

Can you find all the kitchen utensils?

Headless Horse Woman

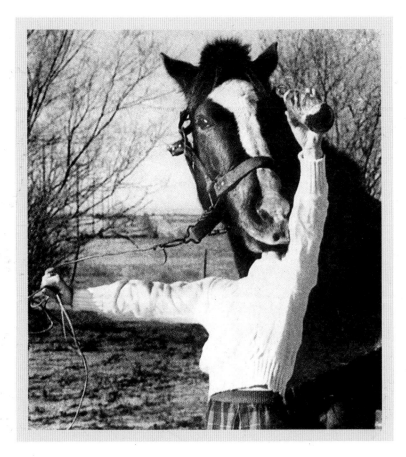

This is what happens when you horse around.

The Thiery Figure

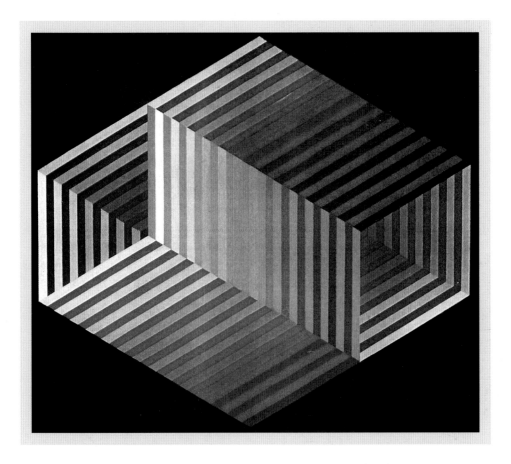

Stare at this figure and it will reverse in depth.

The Woman with Closed Eyes

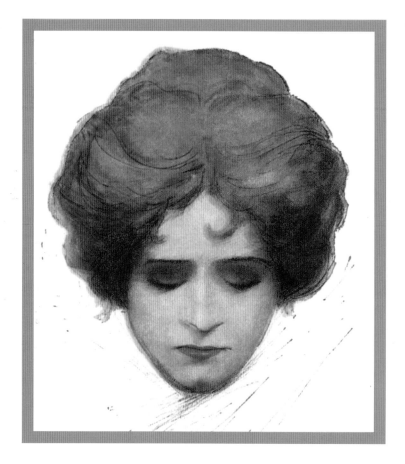

If you stare at this woman long enough she will open her eyes.

Two Cars in One

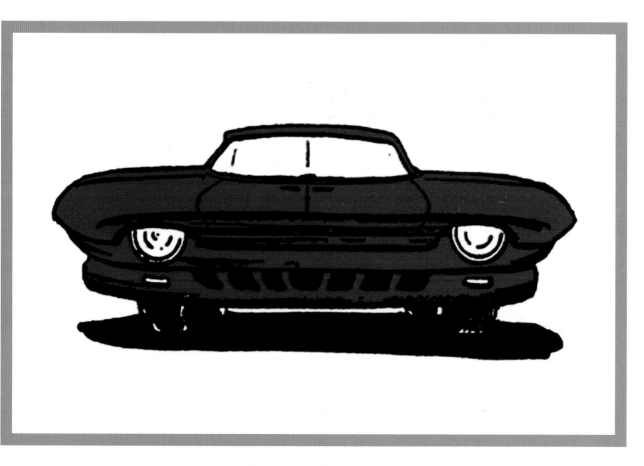

Can you find both cars?

Hollywood

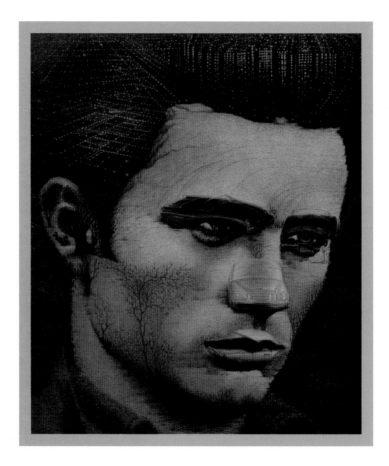

You can see actor James Dean and various icons of Hollywood.

Smell

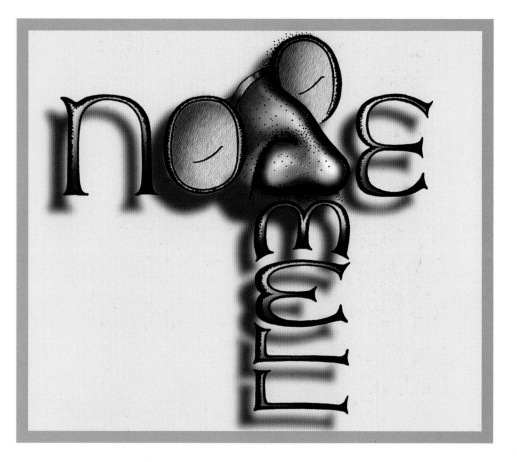

Can you find the words "nose" and "smell" as well as the nose?

Taste

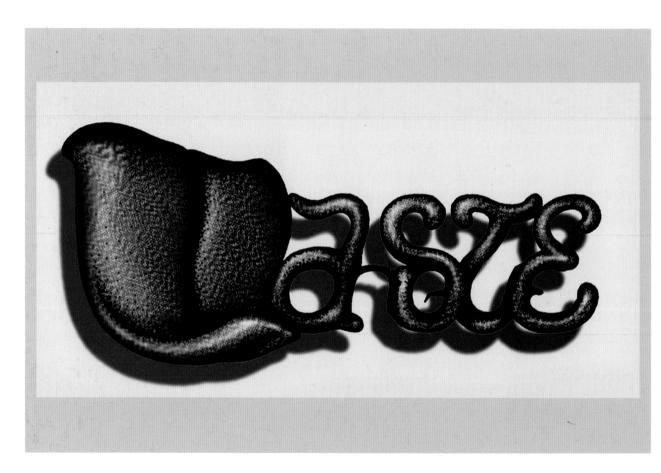

Can you find the word "tongue" hidden in the word "taste"?

Touch

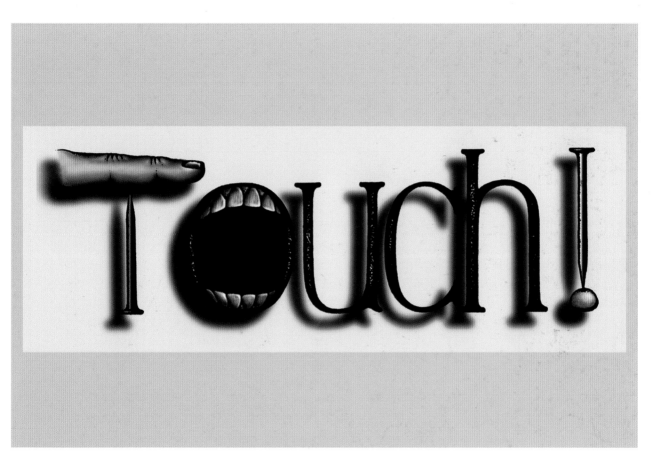

Can you find the words "touch" and "ouch"?

See

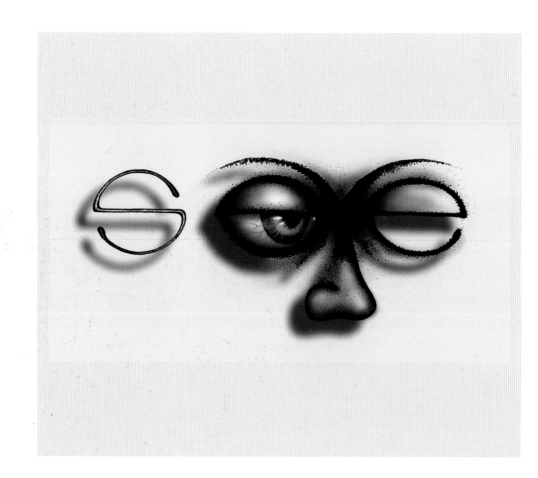

Can you find the words "see" and "eye" as well as the eye?

Hear

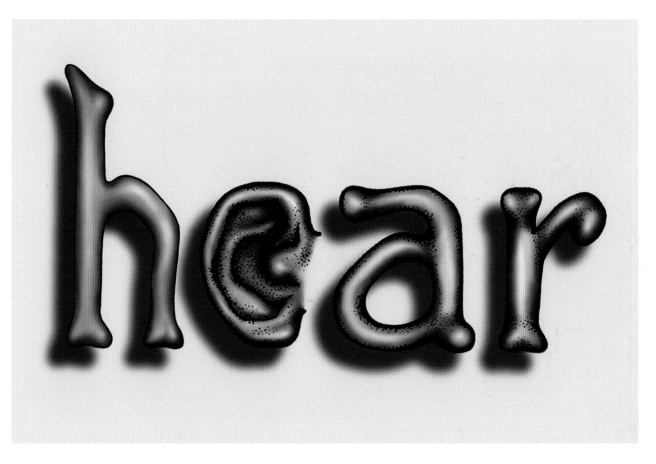

Can you find the words "hear" and "ear" as well as the ear?

Gesture of a Dancer

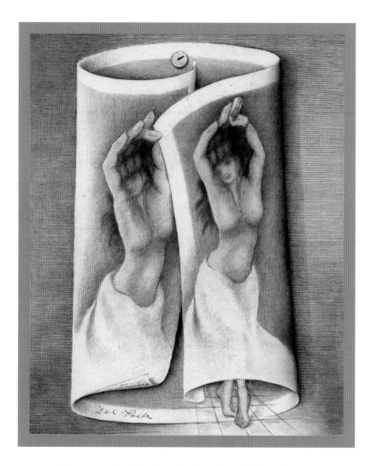

Can you find both the hand and the dancer?

Sara Nader

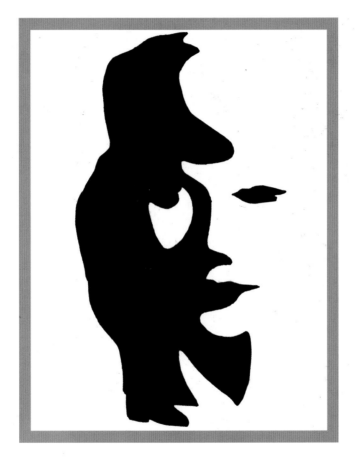

Can you find the woman that the man is serenading?

Hidden Figure

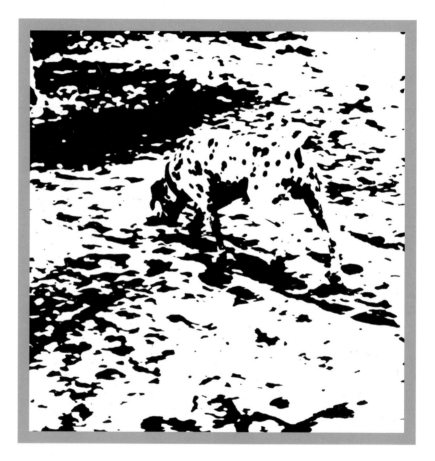

Can you find the Dalmatian dog that is hiding here?

The Goblet/Profile Illusion

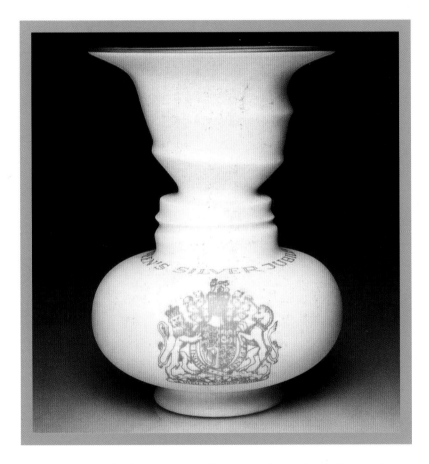

Can you find the two profiles on either side of the vase?

Missing Child

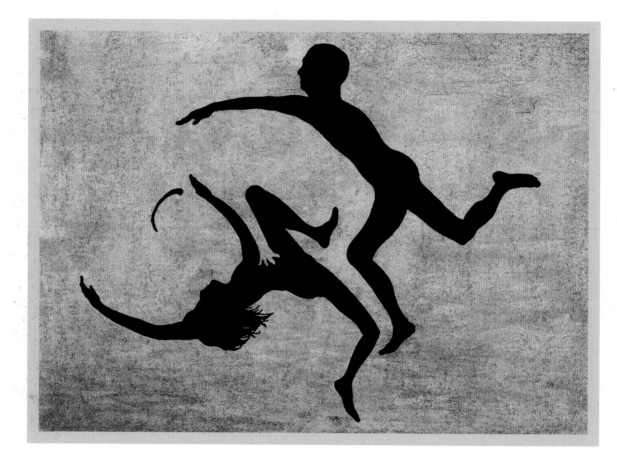

Where is the baby hiding from the couple?

Escher in Italy

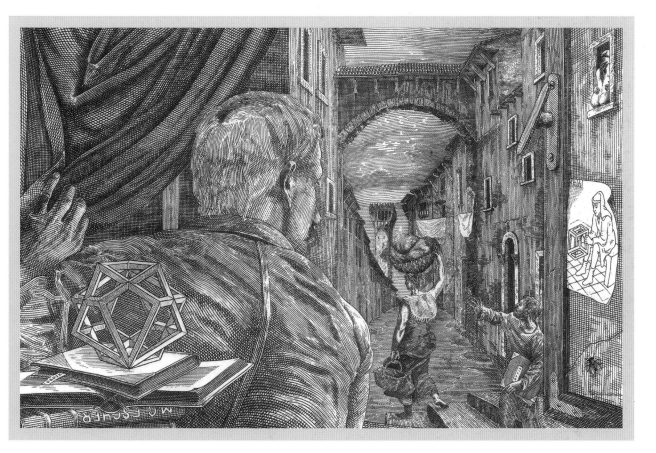

Can you find the hidden portrait of M.C. Escher?

Celeste

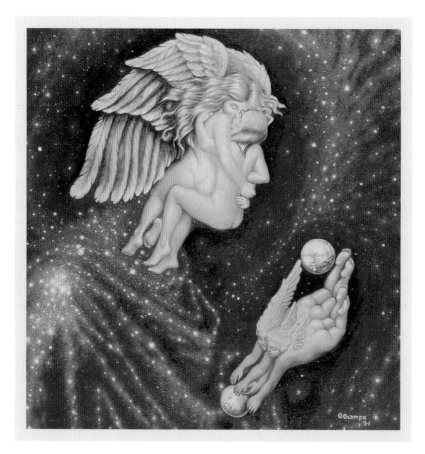

Angels are sometimes made of little angels.

Egyptian Profiles

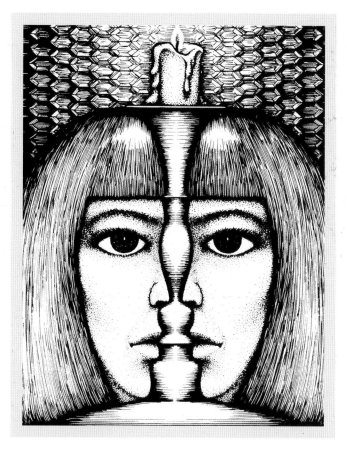

You can see either two heads in profile on either side of the candlestick or one head behind the candlestick.

Bottom's Up!

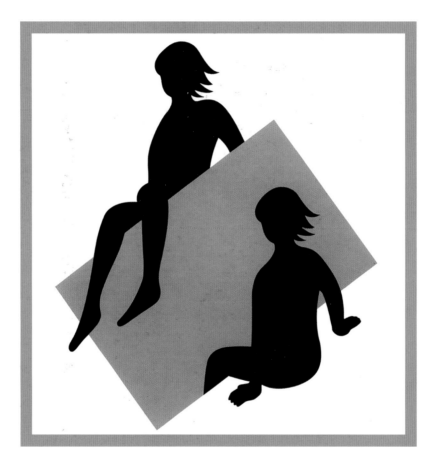

There is something rather strange about this hole.

Father and Son-in-Law

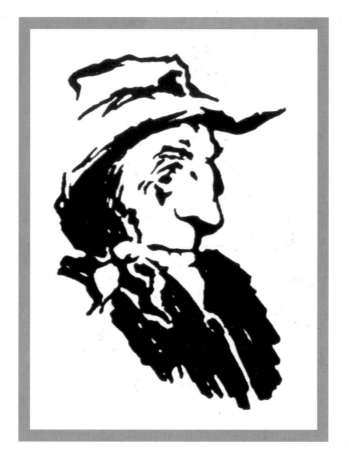

Can you find both the father and the son-in-law?

The Festival of Bacchus

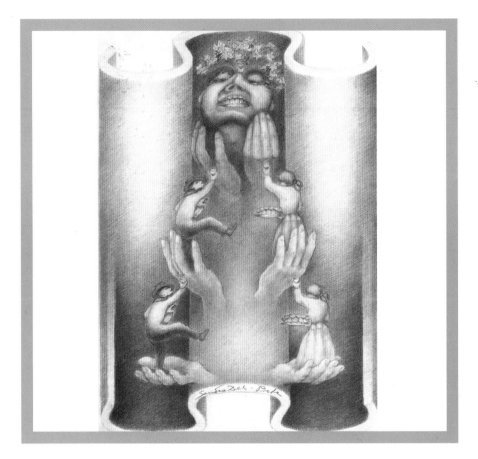

Watch the two people transform into the face of Bacchus
as he brings them up.

A Wobbly Floor

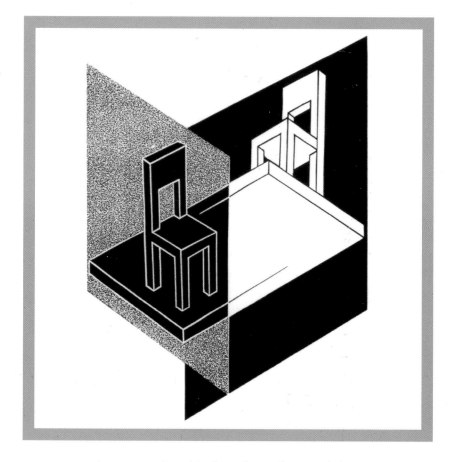

Are you seeing this floor from above or below?

Eskimo/Indian

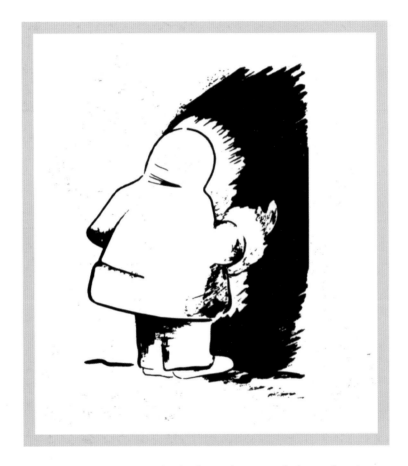

Can you perceive both the Eskimo and the Indian?

Transformation

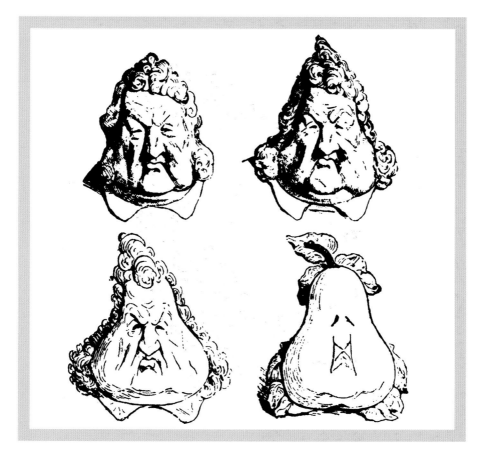

The man transforms into a pear.

Schroeder's Staircase

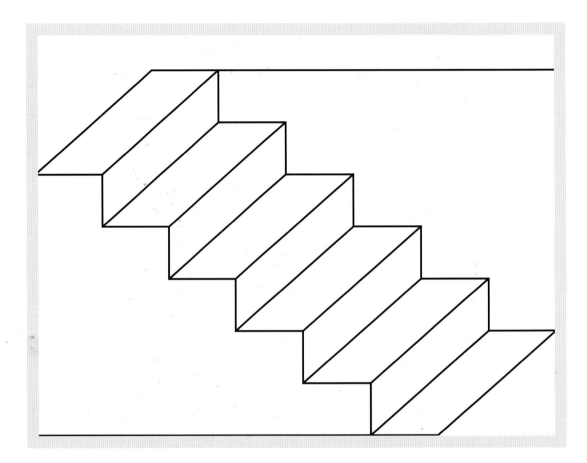

Stare at this and the staircase will invert.

Lupe

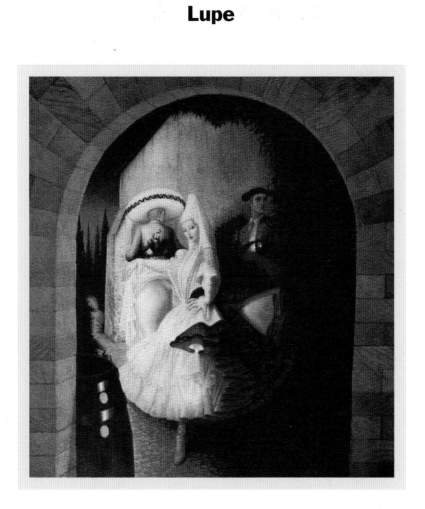

This woman's career is written in her face.

The Human Condition

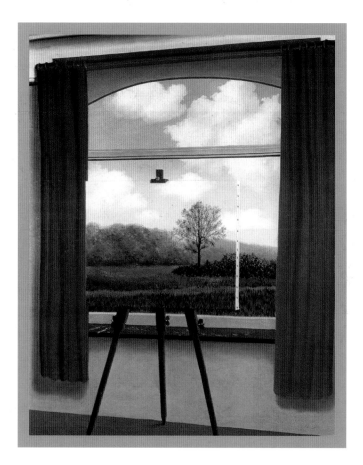

Is the scene on this painting on the outside or inside of the room?

The Mysterious Lips that Appeared on the Back of My Nurse

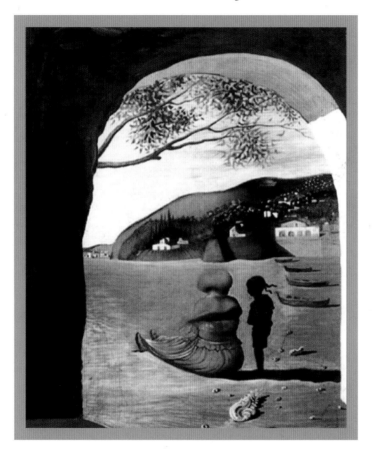

Can you find the face?

Hide-and-Seek

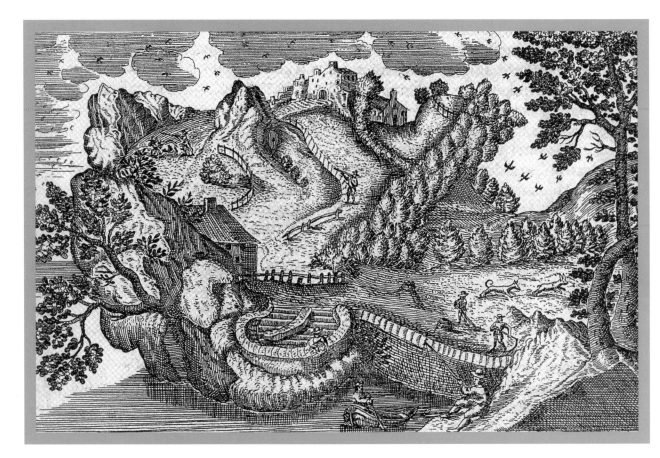

This man is cleverly hiding. Can you find him?

Beckoning Balasters

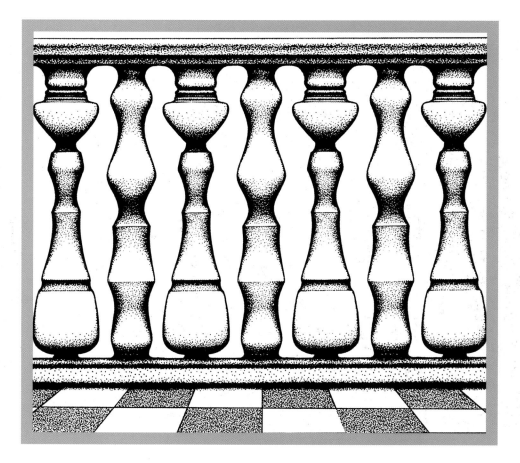

Can you find where the figures are hiding?

Reversing Cube

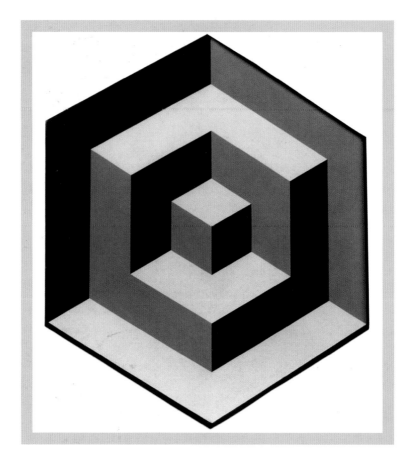

This cube will reverse in depth when you stare at it.

Visions of Don Quixote

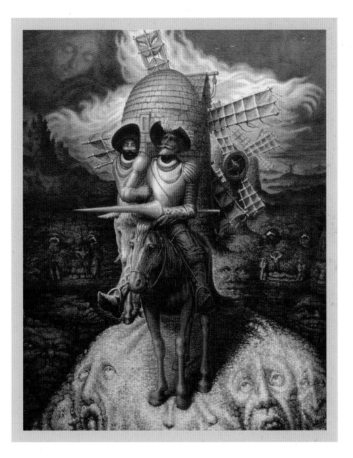

How many hidden faces can you find?

Man of the Mountain

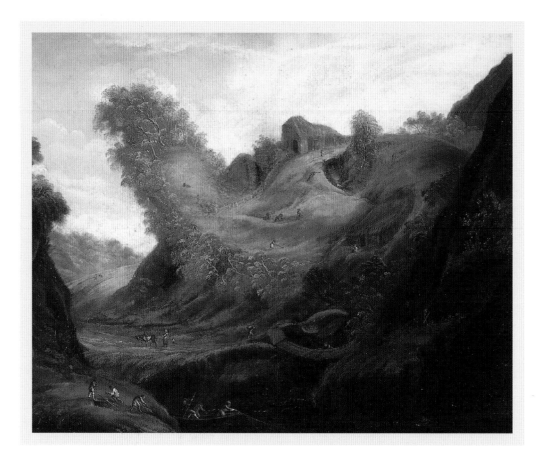

Can you find the man of the mountain?

Beethoven and the Moonlight Sonata

A noteworthy portrait of Beethoven.

Forever

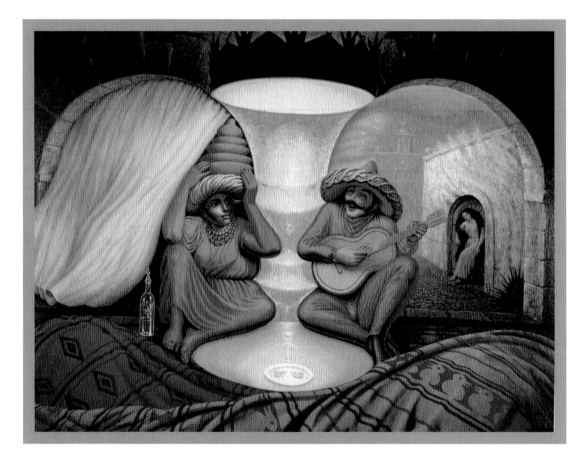

Can you find the vase, the elderly couple, and the two musicians?

Landry's Horses and Clowns

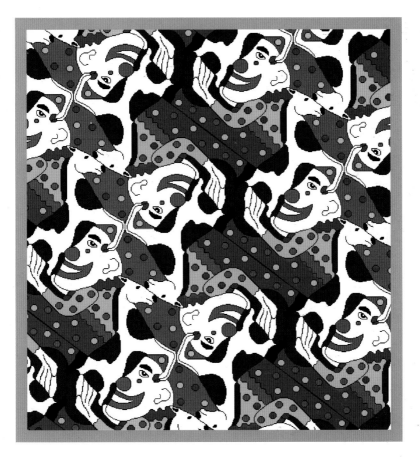

Can you see both the horses and the clowns?

Where is Santa Hiding?

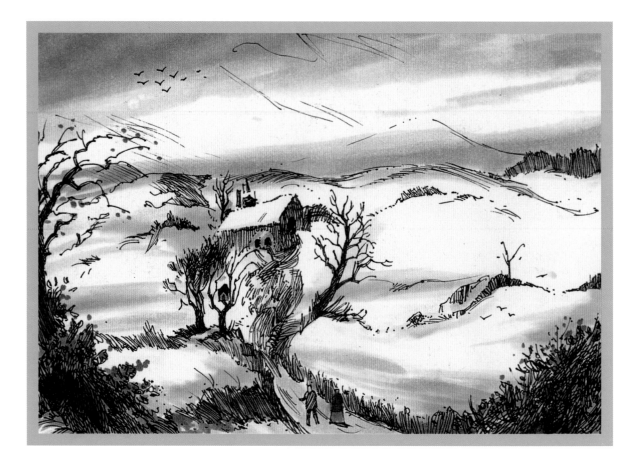

Santa is very clever at hiding. Can you find him?

Figure/Ground Illusion

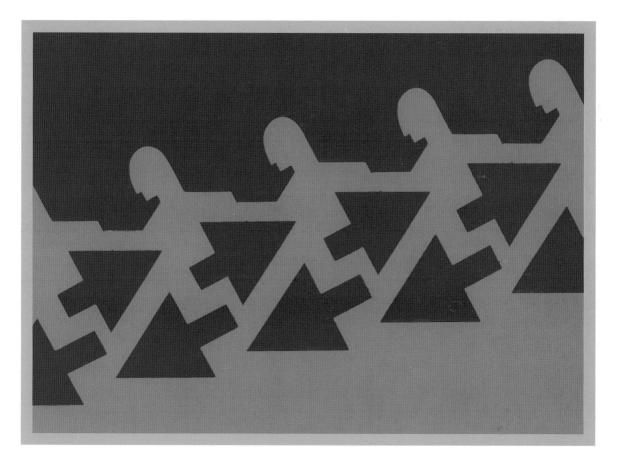

Can you see both the arrows and the running figures?

Cats, Frogs, and Dragonflies

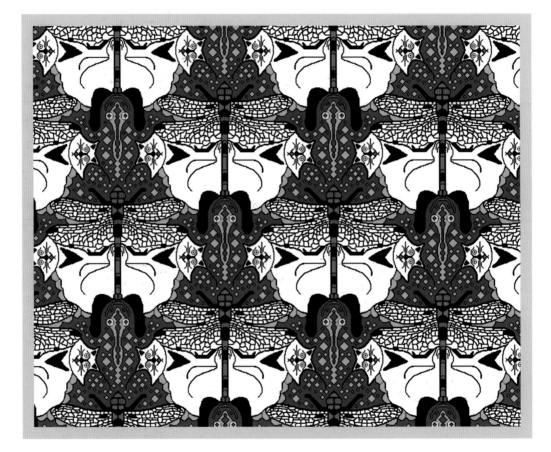

Can you find the cats, frogs, and dragonflies?

Ascent

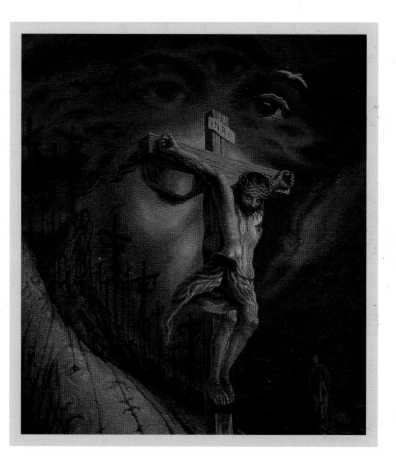

Can you find the large face of Jesus?

Kissers

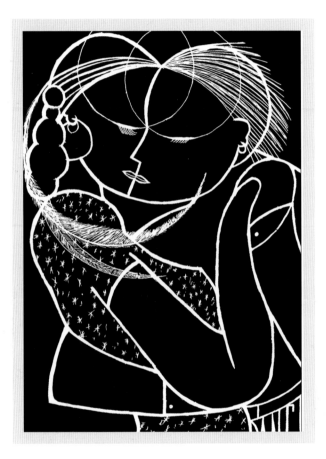

Do you see one head or two people kissing?

Lilies

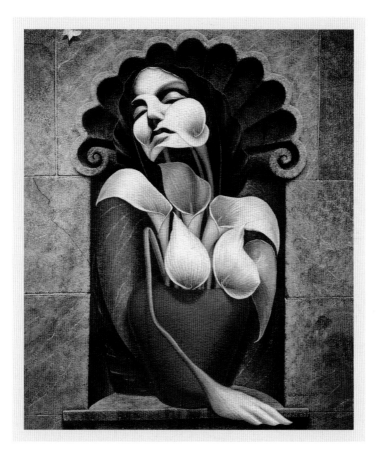

Can you see both the woman and a vase of lilies?

Hidden Message

HOE LEAN ONE

ACE LIE TOUGH AND

EASE CHEST TUCK HID DEBT TART

ALE HEIGHTS WHICH

What does this say? Try reading each line alone quickly.

Nomad

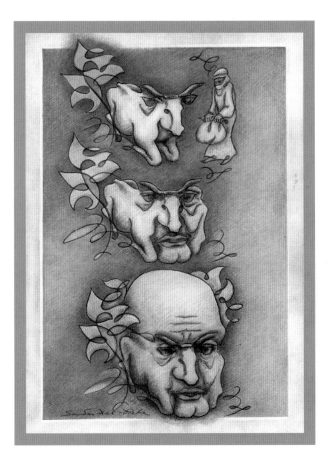

The man becomes one with his Ox.

"God Does Not Play Dice with the Universe"

Do you see the face of Albert Einstein or a lot of dice?

The Impossible Terrace

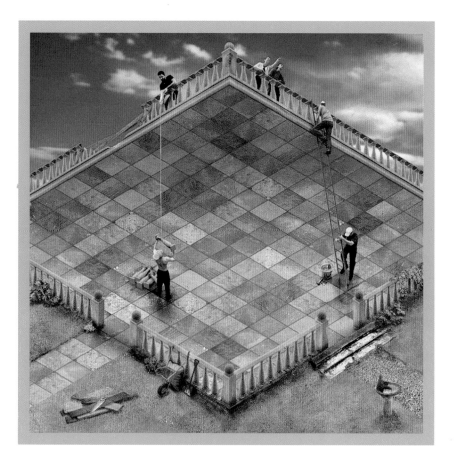

Are you seeing this terrace from above or below?

Speed Reading

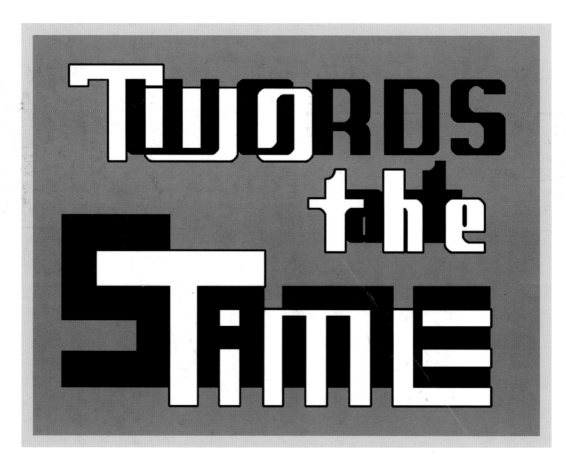

Can you read these two phrases simultaneously?

Vision Test

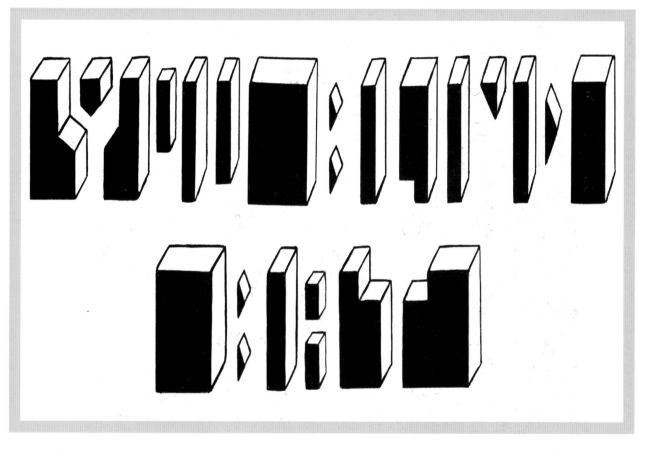

This is a vision test to see if you have developed any visual difficulties from reading this book. Try reading it close up. If this does not work, try reading it from a distance.

Spirit of the Mountain

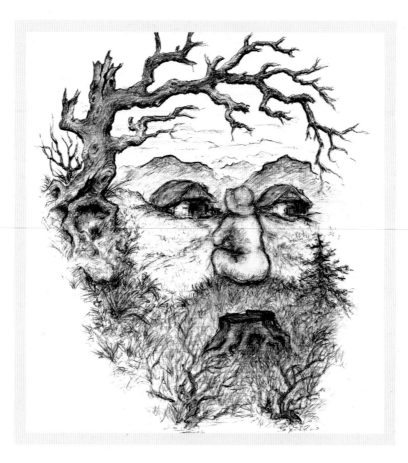

Can you find the spirit of the mountain?

INDEX

ABOUT THE AUTHOR

Al Seckel is the world's leading authority of visual and other types of sensory illusions, and has lectured extensively at the world's most prestigious universities. He has authored several award-winning books and collections of illusions, which explain the science underlying illusions and visual perception.

Please visit his website http://neuro.caltech.edu/~seckel for a listing of all of his books on illusions.